Pump it up Magazine

TABLE OF CONTENTS

⚡ **EDITORIAL** 6
Page 5

⚡ **FELICIA GREEN**
AUTHOR - ENTREPRENEUR
WHAT SHE KNOWS
COULD CHAnGE YOUR LIFE!

⚡ **WHAT'S HOT**
World book & copyright day
International Jazz Day
Top Indie Music Artists

⚡ **REVIEW** 11
How to raise your vibration with music

⚡ **FASHION**
Work From Home Fashion

⚡ **BEAUTY** 18
- Homemade beauty tips

⚡ **MOVIES**
That predicted COVID-19

⚡ **TOP TIPS** 26
Streaming live at home to grow your brand

⚡ **HUMANITARIAN AWARENESS**
Celebrate Earth Day

Pump it up
MAGAZINE

PUMP IT UP MAGAZINE
LINKS

WEBSITE
www.pumpitupmagazine.com

FACEBOOK
www.facebook.com/pumpitupmagazine

TWITTER
www.twitter.com/pumpitupmag

SOUNDCLOUD
www.soundcloud.com/pumpitupmagazine

INSTAGRAM
pumpitupmagazine

PINTEREST
www.pinterest.com/pumpitupmagazine

PUMP IT UP MAGAZINE
30721 Russell Ranch Road
Suite 140
Westlake Village,
California 91362
United States
www.pumpitupmagazine.com
info@pumpitupmagazine.com
@pumpitupmagazine

EDITORIAL

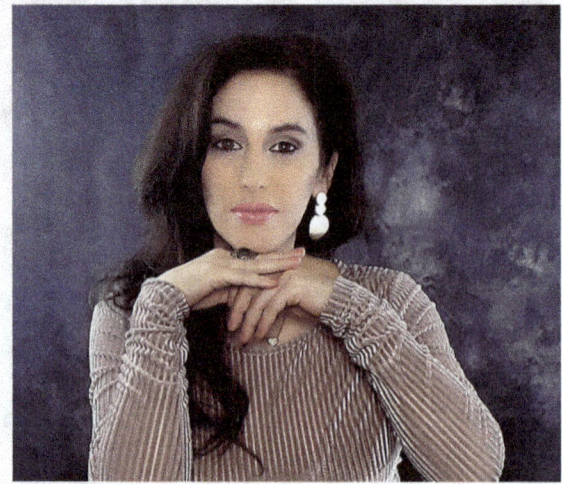

Greetings everyone,

This issue will be called the Social Distancing Spring Edition (just kidding)

I hope all of you are safe and healthy at home and for those who may know of someone or you yourself have been exposed we pray for your good health and speedy recovery.

This is a different time and our world is changing.

We here at Pump It Up Magazine want to encourage every one of our readers to practice Social Distancing, washing your hands and taking good care of yourselves and loved ones.

Speaking of staying at home and finding something to do.

On the cover, we have an exceptional and inspirational author and entrepreneur, Felicia Green and her new book "# Mom Boss!". This is the perfect read for those moms who try to juggle between a job and raising a family. Now that the kids are out of school early and at home, this is a good time to settle down after the kids are in bed and take a literary bath in priceless information that could change your life!

She has another book, "God's Purpose" This book shares her story about how to raise your vibration and turn pain, depression, and abuse into progress and success.

Also inside:

Raising your vibration with music. An informative insight on music heard at a frequency of 432 Hz and how it can improve our lives.

New songs for indie artists
Drivetime
Michael B Sutton
Aneessa

And don't forget to tune in to Pump It Up Magazine Radio!

Be well, safe and blessed!

Best wishes,
Anissa Boudjaoui

CONTRIBUTORS

EDITOR IN CHIEF
Anissa Boudjaoui

MUSIC EDITOR
Michael B. Sutton
Carter Kaya

FASHION EDITOR
Carol Mongo

MARKETING
Grace Rose

PARTNERS

Editions L.A.
www.editions-la.com

The Sound Of L.A.
www.thesoundofla.com

Info Music
www.infomusic.fr

Delit Face
www.DelitFace.com

L.A. Unlimited
www.launlimitedinc.com

Felicia Green
Photography
by
Steve McCoy
@foto_finish_fashion

Felicia Green
Make-Up by
Kim Davis
@professionalmakeupbykimberly

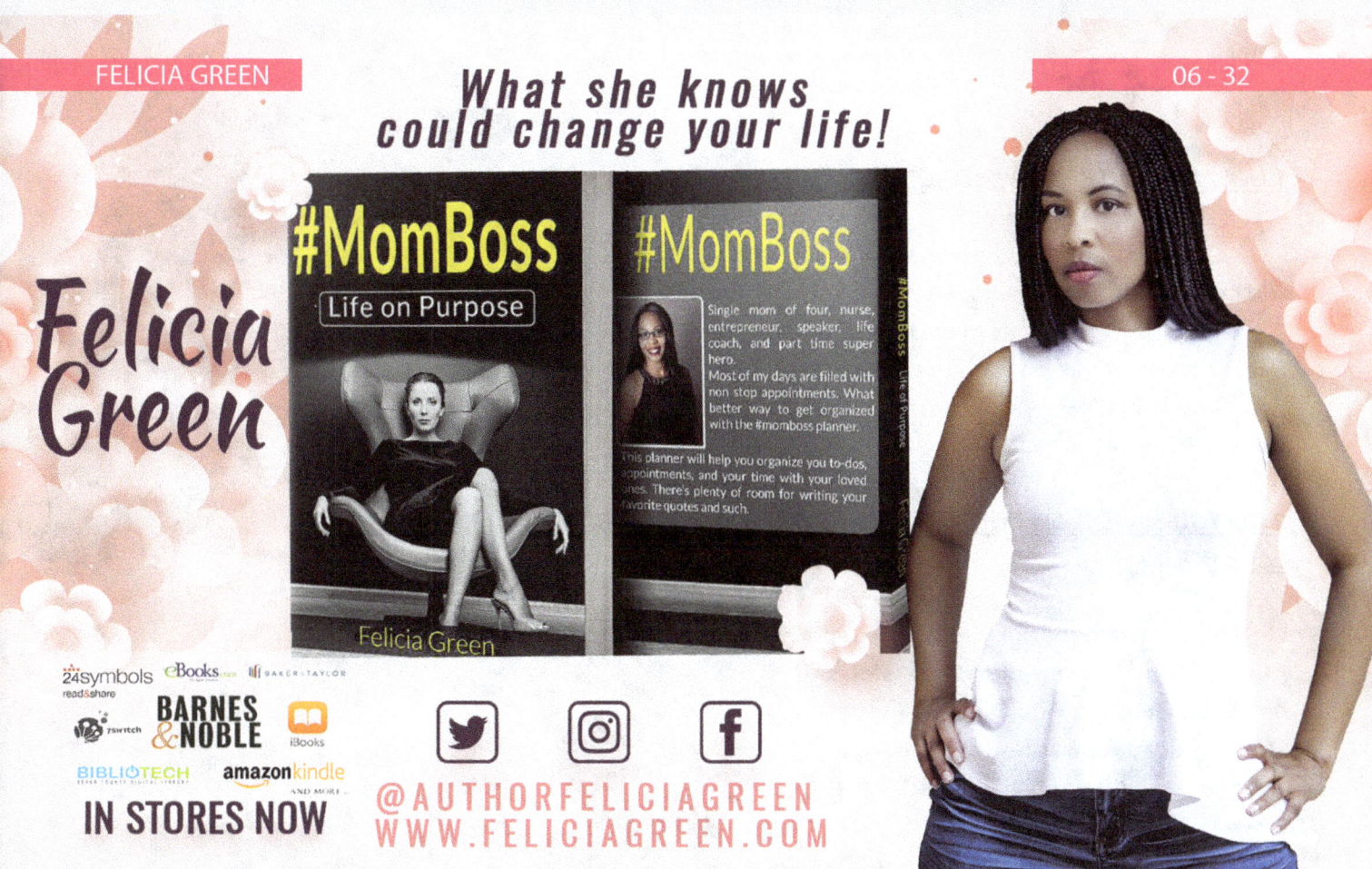

Appointments. Family time. Work meetings. The endless to-do-list that just keeps getting longer and longer. When you're a single mom of four like Felicia Green, you need some kind of way to keep on top of it, otherwise the downward spiral into total chaos is inevitable. In her book #MOMBOSS

Felicia Green gives you the roadmap to living an efficient, supercharged life as a working mom.

The mom boss planner is the method Felicia has been refining for years, to maintain her lifestyle as an all-round super mom. Inside you'll find a daily structure that allows you to plan out your days by the hour and set your most important goals. Sometimes it can feel like we have to make a choice between working and spending time with your loved ones.

But with the #MOMBOSS planner, you don't need to make that sacrifice any longer. Felicia lays out the blueprint that makes it possible to be highly successful in your career, whilst still giving your kids the childhood they deserve. There's even extra space for your favourite quotes to keep you inspired.

From being beaten down by depression and domestic abuse, to becoming a successful entrepreneur, speaker and life coach; the mom boss planner is Felicia's secret weapon to living your best life as a busy parent. She's been a writer and model since just five years old; and through hard-work and a strong faith in God, overcame the struggles of depression, abuse and being a single parent. Felicia's mission is to help guide others going through similar pain, so they can find the same level of freedom and success that she has in her life. #MOMBOSS, is not just here to empower woman, but for anyone who is going through tough times.

FELICIA GREEN

1. HOW DID YOU BEGIN WRITING?

FELICIA: I have been writing and making stories up for my friends and family since I was around 5-6 years old. I love telling stories and to this day my twins ask me to tell them a story and they don't want me to read one they always ask for me to make it up.
So I will just start a story and fill it in as I go. I can make up and entire story within 5 minutes of thought.

2. DO YOU HAVE A SPECIFIC REASON OR REASONS FOR WRITING EACH BOOK?

FELICIA: For the published books the reason was my struggle with dealing with depression and domestic violence. God Can You Hear me was written because I was feeling alone in my struggle and did not feel like God was there. #MOMBOSS is a planner that I created to help me plan out my daily life and how to handle everything on my own. Lastly, God's Purpose was written to show triumph that I found what my purpose is and that God has a purpose for my pain, it also teaches and encourages others to do the same..

3. WHAT AUTHORS DO YOU LIKE TO READ?

FELICIA: I actually don't have a favorite as I am a book lover. I love to read all books from all genres.

4. WHAT BOOK OR BOOKS HAVE HAD A STRONG INFLUENCE ON YOU OR YOUR WRITING?

FELICIA: It would probably be Pricilla Shier. I love her writing style and how she incorporates real family issues or struggles

5. DO YOU MEET YOUR READERS AT BOOK SIGNINGS, CONVENTIONS, OR SIMILAR EVENTS?

FELICIA: Yes I love talking to my readers about my books as well as discussing their aspirations of writing books.

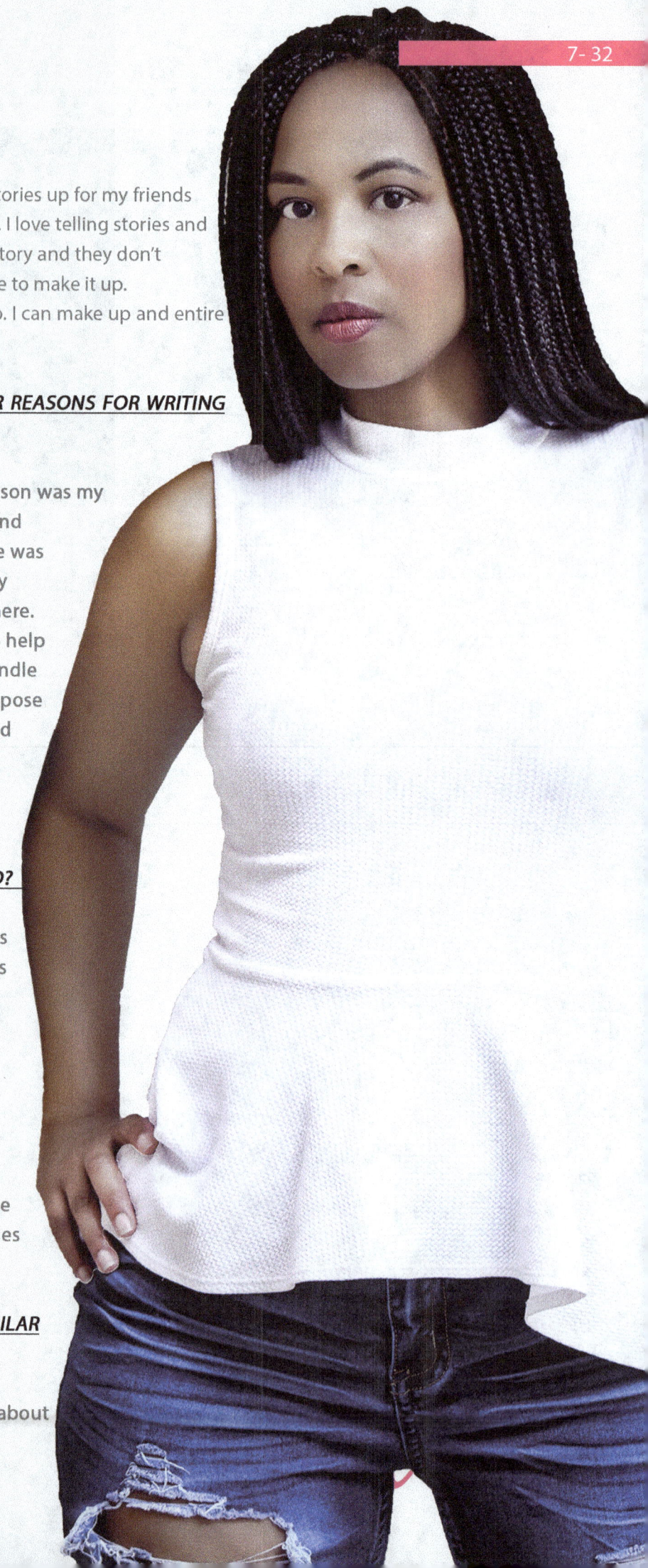

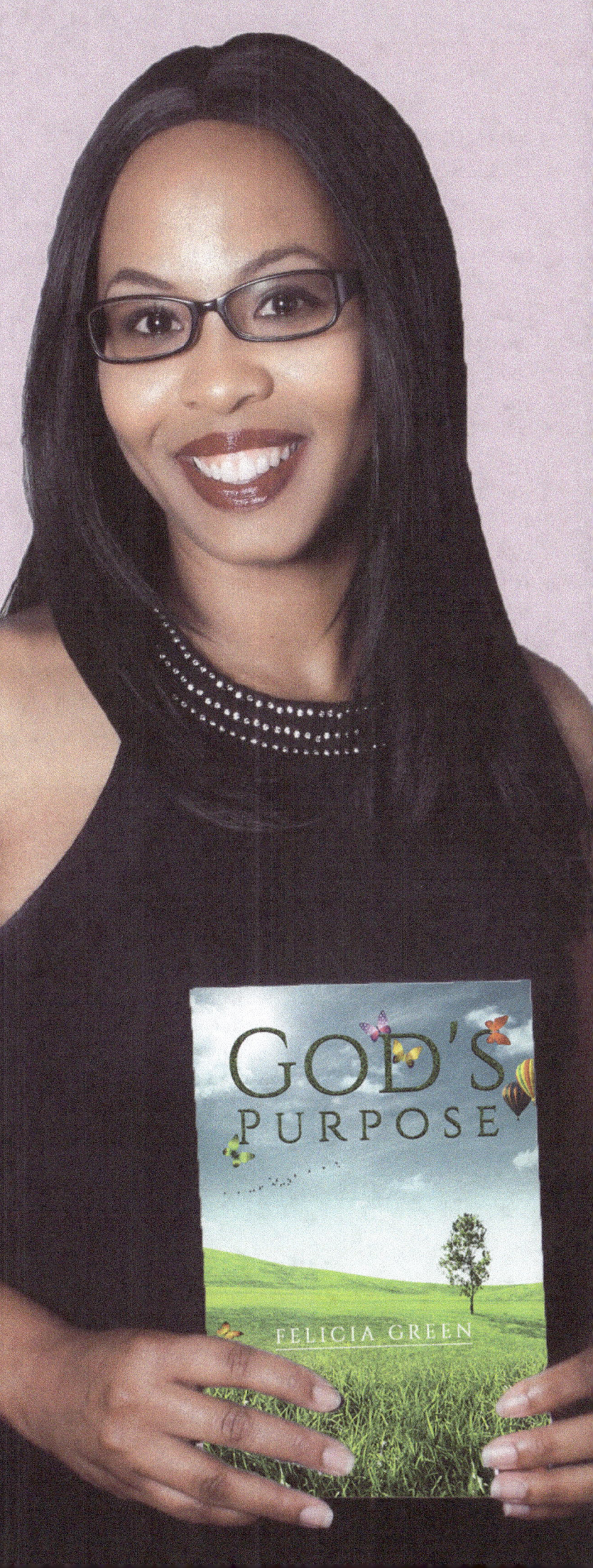

FELICIA GREEN

GOD'S PURPOSE

"I realize that my pain was for a bigger purpose and that the plan that God has for me is more important and will help guide others that are in similar situations."

WWW.FELICIAGREEN.COM
@AUTHORFELICIAGREEN

FELICIA GREEN

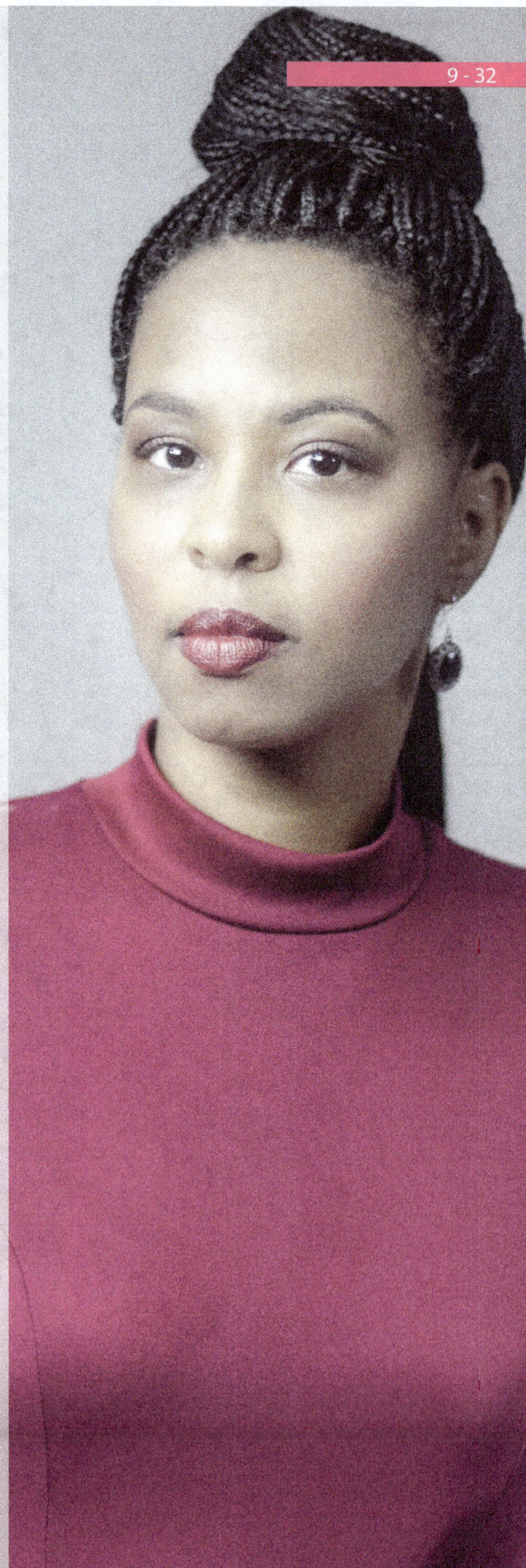

6. TELL US SOME MORE ABOUT YOUR BOOK "GOD'S PURPOSE"

FELICIA: "God's Purpose" was written to show the solidification of my purpose. I realize that my pain was for a bigger purpose and that the plan that God has for me is more important and will help guide others that are in similar situations as well as show them that no matter how you feel you are not alone. God is there every step of the way.

7. YOU ARE ALSO A MODEL, CAN YOU TELL US MORE ABOUT IT?

FELICIA: I actually started modeling when I was in high school around the age 15. I graduated from a modeling school. I did several fashion shows but at that age I don't think I enjoyed as much as I do now. I think at that age I just wanted to be with my friends and do teenage things. I started back modeling due to trying to help someone else get started, and doors started opening for me. So I believe this is part of my purpose as well. To me is signifies strength and boldness, also that I am unstoppable. Domestic violence does not stop me from pursuing my purpose.

8. ANY LAST THOUGHTS FOR OUR READERS?

FELICIA: I hope that my story encourages not just women, but everyone going through something. To let them know that they are never alone and to find people that will support you and know that even if you feel you are alone God is there!

TO KNOW MORE ABOUT FELICIA GREEN, PLEASE VISIT HER WEBSITE:
WWW.FELICIAGREEN.COM

AND FOLLOW HER ON SOCIAL MEDIA
@AUTHORFELICIAGREEN

Felicia Green Photography by Steve McCoy
@foto_finish_fashion
Felicia Green Make-Up by Kim Davis
@professionalmakeupbykimberly

EDITIONS L.A.

GRAPHIC AND WEB **DESIGN**

WEBSITE
CD COVER
LOGO
FLYER
BANNERS
EPK
LYRICS VIDEO
TRANSLATION

We give you the tools to make your song or band to be heard around the world !

**INFO@
EDITIONS-L.A.COM**

WWW.EDITIONS-LA.COM

SPECIAL **OFFERS** 50% ON LYRICS VIDEOS
HIGH-QUALITY MUSIC LYRICS VIDEO
UP TO 1080P HD VIDEO QUALITY
MODERN AND SIMPLE STYLE
$250 FOR MUSIC VIDEO UP TO 4 MIN
$350 FOR MUSIC VIDEO UP TO 5 MIN

FOR MORE INFO VISIT **WWW.EDITIONS-LA.COM**

HOW TO RAISE YOUR VIBRATION WITH MUSIC

Sound is created by this motion up and down, when our vocal strings vibrate or when the wings of an insect go up and down, it creates a sound. A guitar tuned to 432hz means that when one of its string is plucked it will go up and down 432 times per second. Since frequencies spread in their environment, the body of the guitar will start to vibrate along with this frequency, and so will the surroundings of the guitar, including people. The 432hz tuning means that the middle A note will have that frequency. Then all the other notes will tune accordingly on different frequencies along the scale. So 432hz is just a reference point. If you watch any orchestra or band, they will always tune together to the exact same reference point frequency. If even just one instrument is out of tune with the others, the whole thing will sound off.

CONTROLLING THE MASSES, CREATING CHAOS, AND SUPPRESSING MANKIND

Around the second world war, the cabal studied which tuning would be the most harmful for humans, and as a result imposed the 440hz tuning via Goebbels (who thought it was the best for war marches), and JC Deagan. Musicians at the time protested against it but it was pushed through anyway. Almost all music has been tuned to that since then. Music is a powerful influence on our health and vibration. The words, meaning, emotional expression, and most importantly frequency, all affect and program your conscious and subconscious mind. And since most of us are constantly listening to music, it provides a great opportunity to raise your good vibes and find peace; Equally, music provides a great opportunity for the powers that be to control/program the masses with disharmonious frequencies and negative subliminal messages. I would say music is one of the top mechanisms for chaos and control, equal to that of TV.

So, BE CAREFUL WHAT YOU LISTEN TO.

Listening to music that aligns with what you need to overcome, your purpose, or simply whatever makes you feel alive and animated is the major key to raising your vibration. I'm not saying cut out all rap, or sad/angry music!! I still love to listen to some Eminem and songs that don't exactly remind you of peaceful meadows of flowers. It's all about what you get out of the song, and your interpretation of it's meaning. Go through your favorite songs and scrutinize how a song makes you feel, or how the expression resonates with who you are, what your doing, and who your becoming are some things to consider.These are good indicators to know if a song is right for you and the elevation of your frequency and consciousness.

Living artists that lower your frequency: (It doesn't mean they are not good at what they do, or that all songs are bad!)

- MILEY CYRUS
- DRAKE
- KANYE WEST
- TAYLOR SWIFT
- LADY GAGA
- METALLICA
- JAY-Z
- LIL WAYNE
- P. DIDDY (ANYTHING HE TOUCHES)
- BRITNEY SPEARS
- RHIANNA
- JUSTIN BEIBER
- EMINEM AND MANY MORE…

HOW TO RAISE YOUR VIBRATION WITH MUSIC

Living artists that raise your frequency:

- JASON MRAZ
- JACK JOHNSON
- MATISYAHU
- KEITH URBAN
- EDDIE VEDDER
- INCUBUS
- REBELUTION
- FLORENCE AND THE MACHINE
- MOS DEF
- DAVE MATHEWS BAND
- TRACY CHAPMAN
- BRAD PAISLEY
- SOJA
- DARIUS RUCKER

ONLY listen to music that resonates at a frequency of 432Hz. You can convert your favorite songs to 432Hz as I show below, and fight back against the rampant abuse of the disharmonious A-440Hz frequency. (Why you may want to convert your music)

HOW TO CONVERT MUSIC FROM 440HZ TO 432HZ

DOWNLOAD THE FREE SOFTWARE AUDACITY
Then download this little plug-in here in order to be able to save files in mp3

First we need to create a protocol, and then you will be able to apply it quickly and easily to any file or group of files. Open Audacity, click on the 'File' tab on the top left corner, then 'Edit chains', and then 'Add' on the bottom left corner. Enter the name you want for the protocol, for example 432, then click on insert. Then double click on 'TimeScale', and then edit parameters. Then type -1.818 in both (%) boxes and click Ok :

Then click ok again, then click on insert, and double click on 'Exportmp3', and click Ok. That's it ! Click ok to leave this box, and now anytime you want to convert a file, click on 'File', 'Apply chain', select the 432 protocol, and click on 'Apply to files', select the music files you want to convert and it will be done automatically. You can select as many files as you want and the converted files will be placed in a new folder named 'cleaned', inside the folder where the original file was.

***** You can also use certain music players for computer and phones which will play your music in 432hz automatically without needing to convert the files.

However the files will not be converted so if you play them anywhere outside of these players, for example if you upload them on a website or on another device or physical CD, they will be in 440 again. They are still good alternatives as they will automatically play any 440hz tune in 432hz without requiring any work from you

(Note : This protocol is to convert music from 440hz to 432hz. If the music was originally made in 432hz then using this protocol will make it out of tune. Almost all music nowadays is in 440hz, except a lot (but not all) of Indian traditional music which is still made in 432hz, s well as some traditional Tibetan or didgeridoo music, and a few other isolated cases.)

SMOOTH JAZZ – URBAN A/C SONG
ABOUT LOVE THAT KNOWS NO BOUNDARIES

Just to be with you

Aneessa

@ANEESSAMUSIC

WWW.ANEESSA.COM.

WORLD BOOK AND COPYRIGHT DAY

APRIL 23 marks the anniversary of the birth or death of a range of well-known writers, including Miguel de Cervantes Saavedra, Maurice Druon, Inca Garcilaso de la Vega, Haldor Kiljan Laxness, Manuel Mejía Vallejo, Vladimir Nabokov, Josep Pla and William Shakespeare. For this reason, UNESCO's General Conference chose this date to pay tribute to books, the authors who wrote them, and the copyright laws that protect them.

WHAT DO PEOPLE DO?

A range of activities to promote reading and the cultural aspects of books are held all over the world. Many of these emphasize international cooperation or friendships between countries. Events include: relay readings of books and plays; the distribution of bookmarks; the announcement of the winners of literary competitions; and actions to promote the understanding of laws on copyright and the protection of authors' intellectual property.

In some years, the Children's and Young People's Literature in the Service of Tolerance is awarded. This is a prize for novels, collections of short stories or picture books that promote tolerance, peace, mutual understanding and respect for other peoples and cultures. There are two categories: one for books aimed at children aged up to 12 years; and one for those aimed at young people aged 13 to 18 years.

PURPOSE OF THE DAY

World Book and Copyright Day is an occasion to pay a worldwide tribute to books and authors and to encourage people to discover the pleasure of reading. It is hoped that this will lead to the renewed respect for those who have made irreplaceable contributions to social and cultural progress. In some years, the UNESCO Prize for Children's and Young People's Literature in the Service of Tolerance is awarded. It is also hoped that World Book and Copyright Day will increase people's understanding of and adherence to copyright laws and other measures to protect intellectual copyright.

BACKGROUND

The year 1995 was named the United Nations Year for Tolerance and UNESCO's General Conference, held in Paris, concentrated on this theme. The delegates voted to establish an annual occasion to carry the message of tolerance into the future, in the form of a day to celebrate books, authors and the laws that protect them. The date was chosen because April 23 marks the anniversary of the birth or death of a range of internationally renowned writers and because of the Catalan traditions surrounding this day. In Catalonia, a region of Spain, April 23 is known as La Diada de Sant Jordi (St George's Day) and it is traditional for sweethearts to exchange books and roses. World Book and Copyright Day has been held annually since 1995.

SYMBOLS

Each year a poster is designed and distributed around the world. It features images designed to encourage people, particularly children, to read books and appreciate literature. There is also a logo for World Book and Copyright Day. It features a circle, representing the world, and two books, one of which is open.

INTERNATIONAL JAZZ DAY

APRIL 30 has been designated as International Jazz Day by the United Nations Education, Scientific and Cultural Organization (UNESCO).
International Jazz Day celebrates the historical, cultural, and educational contribution of this popular genre of music. The day aims to spread international awareness about this unique musical style; and to promote the cultural, and social values that Jazz stands for.

BACKGROUND

Jazz is a uniquely American musical style that emerged out of the slave experience, primarily in southern United States. It is deeply rooted in the rich musical, and cultural traditions of Africa, and is heavily influenced by European music. New Orleans is generally considered to be the birthplace of this popular musical form, which is now seen as a voice of freedom and empowerment, and a statement against injustice, and oppression all around the world.

Today, Jazz has spread all over the globe, and is constantly evolving, being influenced by, and influencing other musical forms and genres.

The initiative to create an International Day of Jazz came from American Jazz pianist, composer, and UNESCO Goodwill Ambassador for Intercultural Dialogues, Herbie Hancock. The purpose of the initiative was to focus global attention to the role that Jazz has played in breaking down race and gender barriers around the world; and in promoting cooperation; mutual understanding, and communication; peace and freedom.

CELEBRATIONS

Several activities mark the celebration of International Jazz Day, including Jazz concerts and performances, film screenings, and conference and panel discussions.

Due to ongoing concerns about the spread of the coronavirus, the International Jazz Day 2020 Global Host Celebration in Cape Town and other cities across South Africa, including the All-Star Global Concert on April 30, will not take place as scheduled.

We suggest everyone to unite and broadcast online performances on April 30 under the motto "Peacekeeping Jazz!". All organizers of International Jazz Day and musicians come together in this day. And together we will overcome all troubles and difficulties. I wish you health and peace!

International Jazz Day would not be possible without the thousands of independent organizers around the world who faithfully help bring the message of this unique music into their communities each year on April 30. We strongly encourage our partners to follow all local public health directives and government guidelines when considering whether to go ahead with an International Jazz Day program. Many partners have already rescheduled their programs for a later date, pending the abatement of the current global pandemic. These postponed events will be gratefully recognized as official celebrations of International Jazz Day. Read more at www.jazzday.com

YOUR MUSIC CONSULTANT

"YOU BELIEVE, SO DO WE!"

We Can Help You To Grow Your Business

We are a monthly based service, we put faith in artists who has major potential, believed in them, and who are willing to spend their time and own money to work with us in building a successful music career!

Digital Marketing Services

SOCIAL MEDIA - STREAMING SERVICES - MUSIC DISTRIBUTION - PRESS RELEASE - PRESS DISTRIBUTION - PR

Radio Airplay and TV Commercial

TERRESTRIAL AND DIGITAL RADIO CAMPAIGN AL GENRES EXCEPT HEAVY METAL -
CABLE TV AND MAJOR NETWORK COMMERCIAL

Licensing & Booking

CONCERTS, LIVE MUSIC, EVENTS, CLUB NIGHTS - RED CARPETS -
FOREIGN LICENSING AND SUBOPUBLISHING

Why Choose Us ?

3 DECADES OF MUSIC BUSINESS EXPERIENCE
Platinium and Gold Records
MOTOWN RECORDS
UNIVERSAL
SONY
CAPITOL RECORDS

WE WORKED WITH:
Kanye West - Jay Z - Stevie Wonder - Michael Jackson - Germaine Jackson Smokey Robinson - Dionne Warwick - Cheryl Lynn - The Originals -

📞 **1 -818-514-0038**
(Ext. 1)
Monday - Friday / 9am to 6pm

FIND US :

www.YourMusicConsultant.com
30721 Russell Ranch Road Suite 140 Westlake Village, USA
Email : info@yourmusicconsultant.com

TOP INDIE MUSIC ARTISTS

POP-R&B-JAZZ-GOSPEL

"FALLING (THOSE WORDS)"
MICHAEL B. SUTON

"JUST TO BE WITH YOU"
ANEESSA

"PHATT"
DRIVETIME

"SETTLE ME"
BISHOP JULIAN TURNER

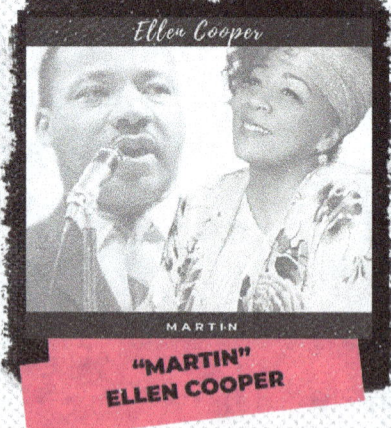

"MARTIN"
ELLEN COOPER

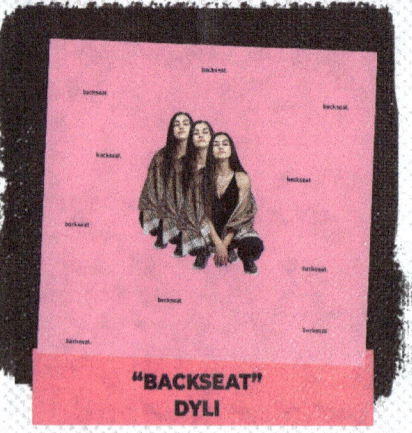

"BACKSEAT"
DYLI

TUNE IN TO
PUMP IT UP MAGAZINE RADIO

 Pumpitupmag Pumpitupmagazine Pumpitupmagazine.

WWW.PUMPITUPMAGAZINE.COM

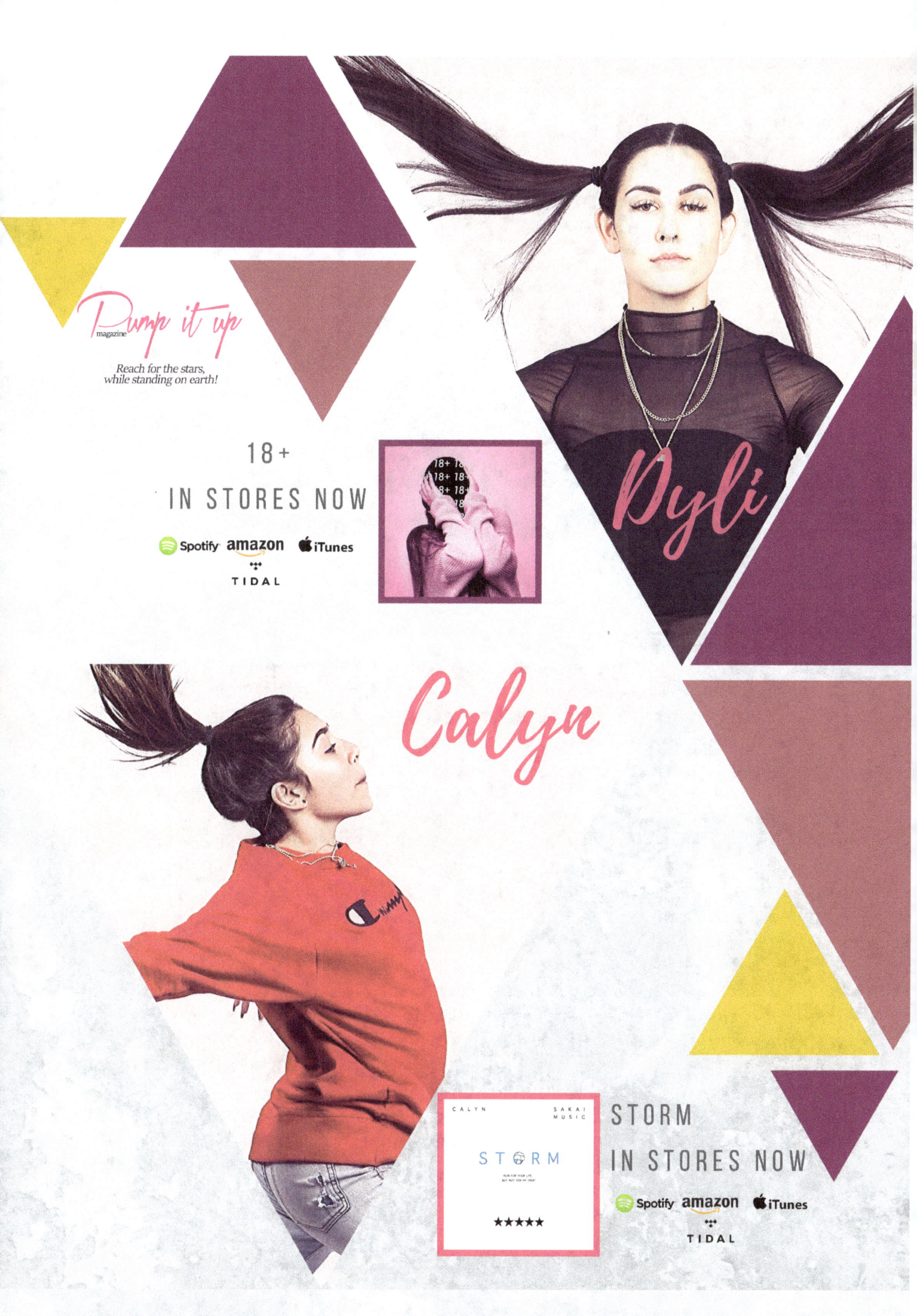

BEAUTY TIPS | HOME MADE

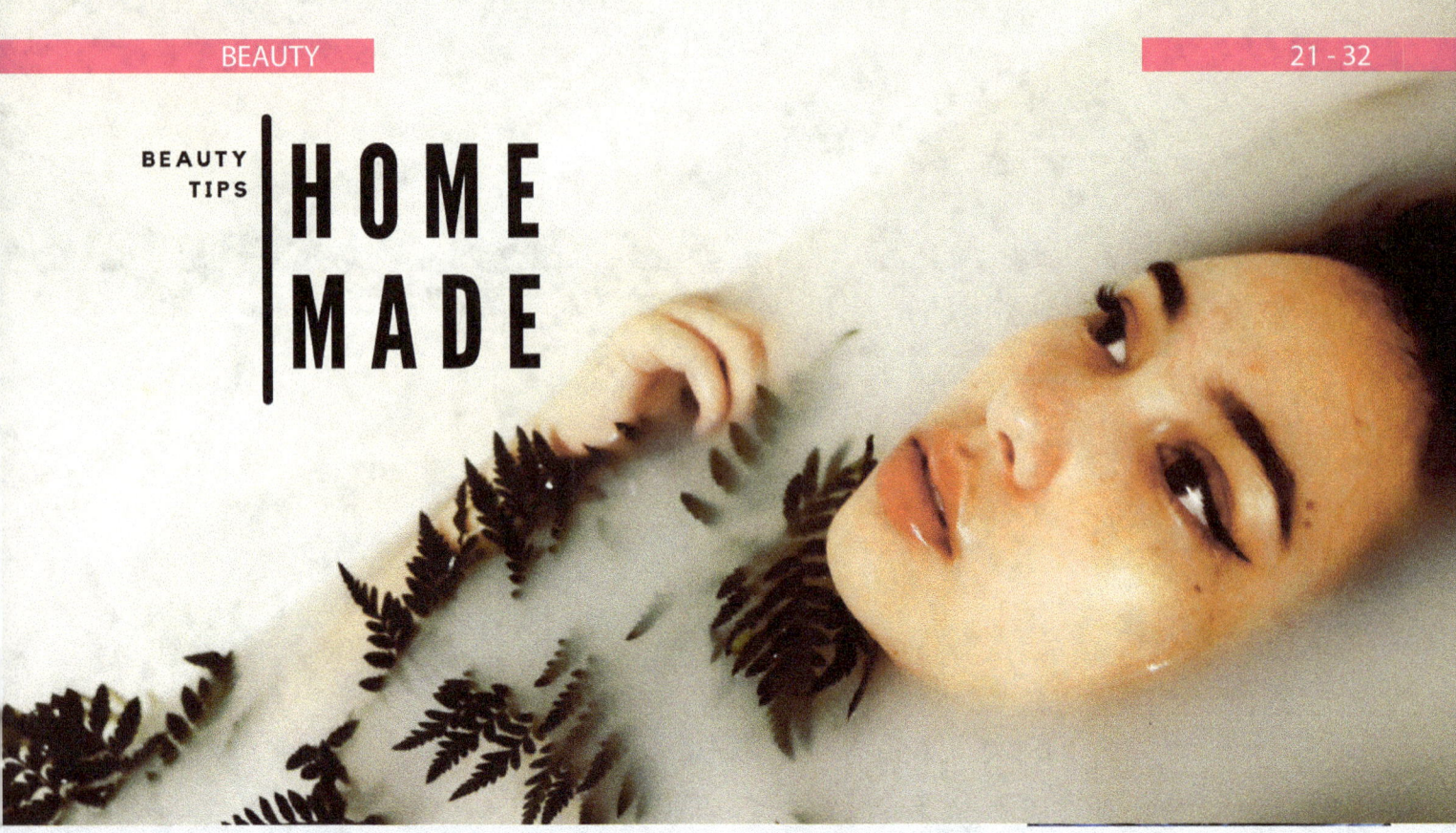

ESSENTIAL AND NATURAL HOMEMADE BEAUTY TIPS FOR FAIRNESS SKIN THAT PEOPLE SHOULD DEFINITELY TRY OUT AND FOLLOW ON A REGULAR BASIS.

1. AVOCADO AND RICE POWDER MASK:

This is not only a mask but this is also an exfoliator. This is very good for people having dry and sagging surface. People who has dryness and needs Moisturization they can benefit with this. The powder will help to exfoliate and the avocado contains excellent moisturising properties. These can be very helpful.

People can mix about 1 cup of pulp of avocado which should be ripe and to this about half a teaspoon of grained rice powder.
This should be applied normally and then after 20 minutes, this should be washed off by scrubbing in gentle motions.
The mask will soften the surface and then it can be scrubbed easily.
This should be done as per requirement which can be twice a week.

2. LEMON JUICE AND OLIVE OIL MASSAGE FOR FAIRNESS SKIN:

This is very good for those having sagging and old surface. This can be good for those who have clogged pores because warm olive oil will help to open the ores. At the same time, the lemon juice helps to mildly bleach the surface and give a glowing effect.
About 1 teaspoon of good brand olive oil can be taken and slightly warmed up.
To this about 1 teaspoon of fresh lemon juice can be mixed.
Massage on for about 6 minutes and then wash off with a cleanser.
This should only be done a few times a week.
This should be avoided or the lemon juice used in less quantity if these is irritating to the person using this.

3. TEA BAG SOAK FOR TIRED EYES:

This is a very popular method to soothe the tired eyes. People having dry or dullness around the eyelids, can try soaking tea bags in warm water and then take these to get chilled in the refrigerator.
Then these can be put directly over the area and then the person can lie down for about 15 minutes. This is the treatment time. Then the eyes and also the surrounding area will feel freshen. This can regularly be followed to get rid of any patches or even bags.

4. APPLE AND HONEY PACK FOR FAIRNESS SKIN:

This is a moisturizing and anti oxidant mixture. This can be used even when a person is doing fruit facial. This can be a good thing for a paste that can make a person freshen. This rejuvenated and also makes dull surface to improve the complexion. The honey is also anti bacterial and therefore can be good for those having rashes. It is also good for those who need excessive Moisturization. This can be quite helpful to them.

The apples can be peeled and then grated.
The juice can be squeezed out and then mixed with honey about 2 tablespoons or as per requirement.
This can be applied for about 20 minutes and then washed off.
The antioxidants will get soaked and give freshness.

5. STEAM IT CLEAR:

One of the easiest way to get a clear and fair skin within minutes it to opt for a face sauna where you hover over a warm water bowl possibly with a few drops of essential oil in it as you lock in the area with a overhead towel and allow the steam to make wonders on your face. Steaming is always best beauty tip for fairness skin.

6. SCRUB AWAY FOR FAIRNESS SKIN:

Scrubbing is an integral part of skin lightening where the scrub often made of grainy ingredient helps you relax your skin whilst improving blood circulation while the coarse face pack draws out the underlying dirt and moisture and cleanses and clears up your face. To make a good homemade scrub simply use grained sugar and salt with a tea spoon of yogurt to make a mixture. Massage well before washing off.

7. LEMON HONEY PACK FOR FAIRNESS SKIN:

Lemon is considered a good exfoliator as the citrus in it seeks and clears out the dirt and lightens the skin from the dermal layers. Honey is considered a natural soother that brings a warm glow to your skin. so why not mix these two for good homemade beauty tips for fairness. Squeeze some lime or lemon with some honey and use it as a pack.

TOP TIPS

LIVE STREAM AT HOME TO GROW YOUR BRAND

Live streaming can be a fun, rewarding, and incredibly valuable tool for growing your brand in an online space.
Live streaming helps to nurture the growth of your brand in the online space. Here's a few streaming tips to maximize your brand's ability to reach the maximum number of potential viewers.

SHARE YOUR LIVE VIDEO IN FACEBOOK GROUPS.

Facebook Groups contain users that have a particular affiliation or share an interest in a specific topic. For example, there could be a Group for dog lovers, live streaming enthusiasts, or entrepreneurs. If there is a subject of interest, you can bet there is a corresponding Facebook Group. The trick is to find and join groups that are relevant to your live video content, and then spread the word about your live stream to attract new viewers and grow your brand.

USE ON-SCREEN TEXT

Live video posts are shown in a user's newsfeed with the volume muted by default. And since Facebook users typically scroll quickly through their feed, it's a risk your video will get lost in the crowd. It's therefore a good idea to include the occasional use of text in your lower thirds to provide a snapshot of what the video is all about and attract the attention of potential viewers.

TITLE TEXT MATTERS!

We admit that coming up with catchy titles can be tricky sometimes, but a well-written title is highly valuable. Not only are quality titles attractive to a potential viewer, but titles are also essential for SEO (especially on YouTube). Search engines like Google can't read video content to see what your page is all about, so it's important to place your keyword in your video's title, description and video tags.

LIVE STREAM TO MORE THAN ONE PLATFORM

Publishing your live stream to multiple platforms, such as YouTube and Facebook Live, is an excellent way to reach more viewers with very little extra effort. The additional encoding required places more stress on your processor, so we recommend using a powerful, dedicated encoder for multi-streaming.

BE CONSISTENT!

Go live at a regular time to help build a following. An inconsistent and irregular frequency of live streams will only frustrate your audience. Consistency in your schedule also makes it easier to market and promote the show.

FASHION

Work From Home Fashion

We already know that the coronavirus outbreak is affecting the fashion and footwear industries in seismic ways. From supply chain halts in China and manufacturing woes in Italy to a steep drop in showroom visits and retail orders as fashion month drew to a close at Paris Fashion Week (just as the global outbreak was ramping up), the economic implications are just starting to reveal themselves.

At its core, fashion is incredibly emotional and in a real crisis, people mostly want to feel some comfort — a metaphorical security blanket but also, a physical one. Will cozy knitwear and those trending cashmere sets become an even bigger sell? Do robes and hoodies hold a renewed allure? Will retailers start selling out of slippers as everyone stays indoors and and there is no longer current use for a pair of stiletto pumps or platform sandals?

At Paris Fashion Week, amidst growing concern that the coronavirus was following the fashion industry, Joseph Altuzarra combined elegant necklines and vintage ladylike silhouettes with sumptuous knits and fuzzy slippers. In the context of the unraveling crisis, his collection took on more significance.

A knit onesie and shawl from Rag & Bone's fall '20 collection.

FASHION

On the footwear front, fall's practical boot trend is perfectly timed. This will not be an era of sequins, silks and other frivolities. Rubber soles can be more easily wiped down and already-trending heavy lugs give off an apocalyptic vibe that might actually empower its wearers in its armor-like silhouette.

In real life, as people begin to navigate work-from-home strategies, including virtual meetings on FaceTime, Google Hangout and the like, perhaps the most important fashion question is what to wear from the waist up. To this, a portrait of Phoebe Philo comes to mind.

In the shot, photographed by David Sims in 2010, the designer covers her mouth with a chunky turtleneck sweater. Cozy, practical, still professional, the trusty turtleneck is likely to hold court as one of the most ubiquitous items during this time. Worn Phoebe-style, its design also offers a sense of protection, even if only symbolic

And though you won't be able to see them on most FaceTime calls, it's a good bet that the fur-lined sandal — another Philo signature — will also come creeping back to life. Because in these times, comfort as the ultimate luxury will take on a whole new meaning.

A fuzzy coat and practical rubber boots from Stella McCartney fall '20.

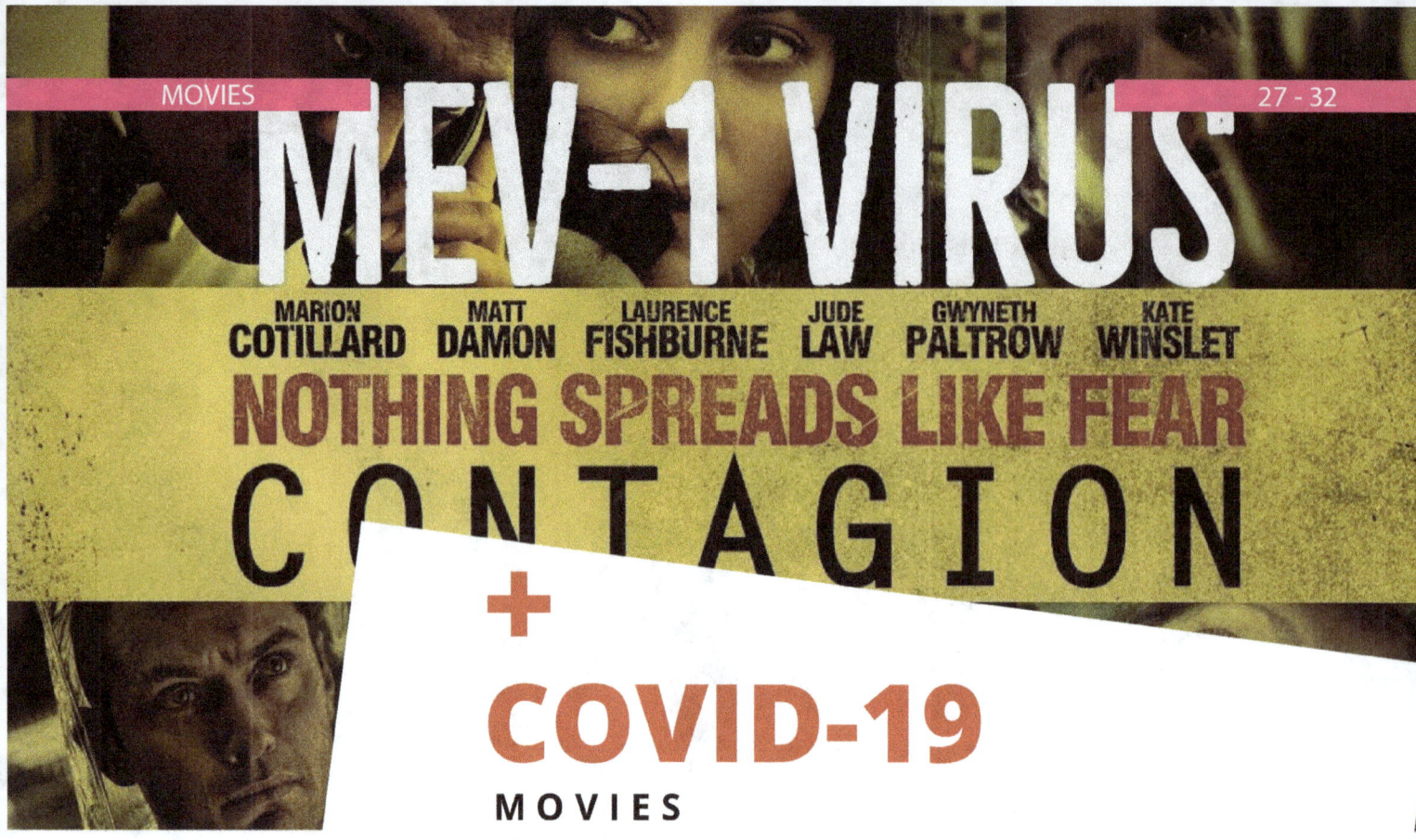

+ COVID-19 MOVIES

A lot of people are currently looking at weeks, if not more, of at-home quarantine or social distancing.

If you're one of the ones who can't get enough of coronavirus disease 2019, you might find yourself looking for movies or shows to binge while you sit at home.

CONTAGION

For all those examples, "Contagion" correlates most directly with the current danger, beginning as it does with a woman (played by Gwyneth Paltrow) who returns to Minnesota with a strange illness after a trip to Hong Kong.

How "Contagion"; spread to the big screen

In a matter of days, she's dead, leaving her husband (Matt Damon) in a state of shock, before others begin exhibiting the same symptoms, as the outbreak spreads across the world.

Directed by Steven Soderbergh and written by Scott Z. Burns, the movie offers an alarming glimpse at a worst-case scenario. Rumors and panic begin to spread, and the guardrails quickly start to come off society as the days click by, amid quarantines, looting and chilling scenes of vacant airports.

Watching the movie again, what stands out -- beyond an inordinately good cast that includes Kate Winslet, Jude Law, Laurence Fishburne, Marion Cotillard and Bryan Cranston -- is how difficult it is to convey the global sweep of such a story without sacrificing something in terms of the drama.

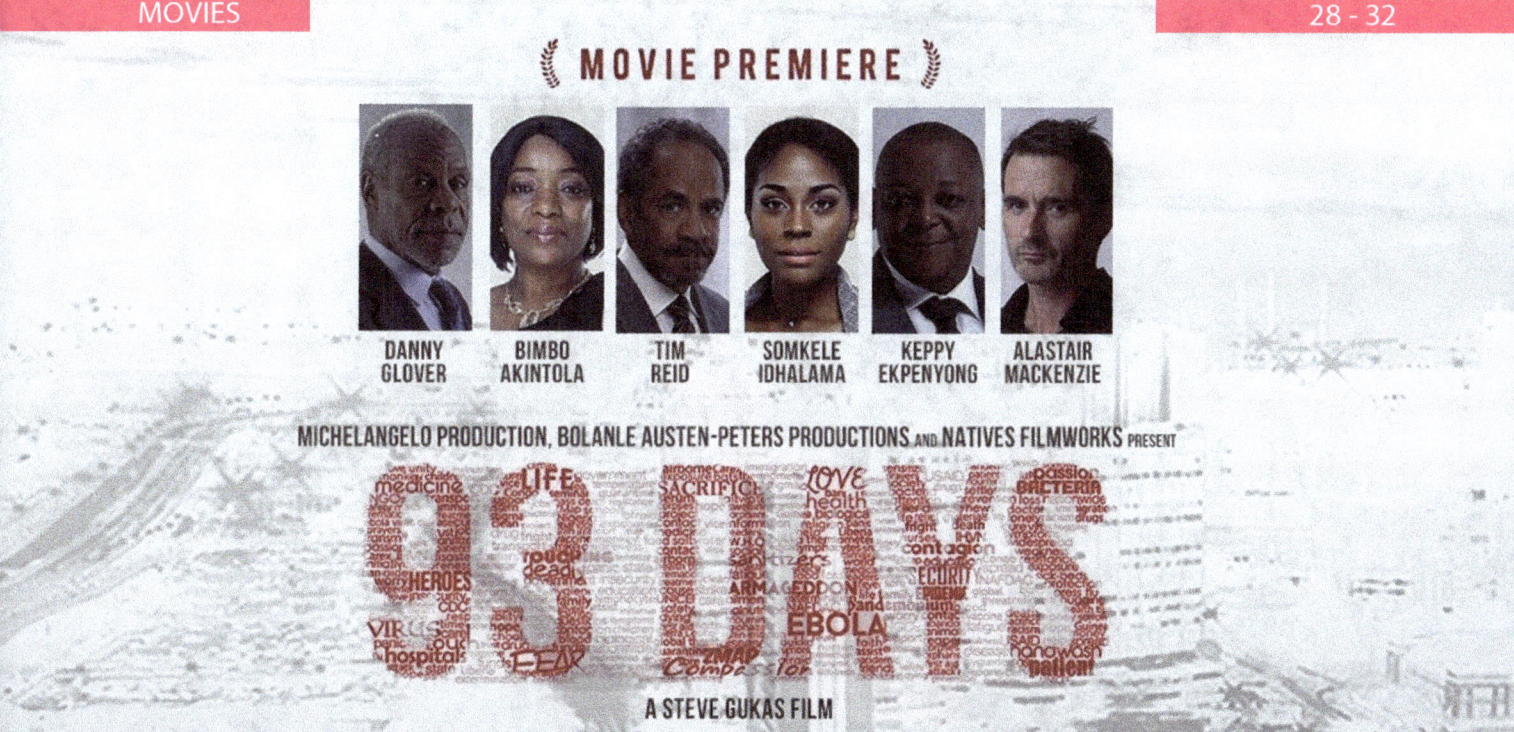

93 DAYS

Starring Danny Glover, Bimbo Akintola, Keppy Ekpenyong, Somkele Iyamah Idlahama, Tim Reid, Alastair MacKenzie, Gideon Okeke and more, the film tells the true story of Nigeria's successful eradication of the Ebola Virus when it broke in 2014.

From its private screening at The U.S Department of Health and Human Services (HHA) to a sold out World Screening at The Toronto International Film Festival (TIFF), 93 Days has received remarkable commendations as a masterpiece.

"The key was collaboration and to see how much we can achieve. The collaboration really changed me. It was important for me to be in this film because of the message. Nigeria is a dynamic great country, it's a country where the people are challenging themselves. This is an example of how they challenged themselves and succeeded. I'm so proud to be a part of it" –
Hollywood actor, Danny Glover (played Dr Ohiaeri).

"This movie is the best I've seen in a long time! Great actors, great way of telling a story and great way to tell the world about the Nigerian team effort that saved the country. Thanks for spreading the message. We need to be prepared for infectious diseases"–
HHS, Director of International Health Security.

93 Days is produced by Bolanle Austen-Peters, Dotun Olakunri, Pemon Rami and Steve Gukas.

MOVIES

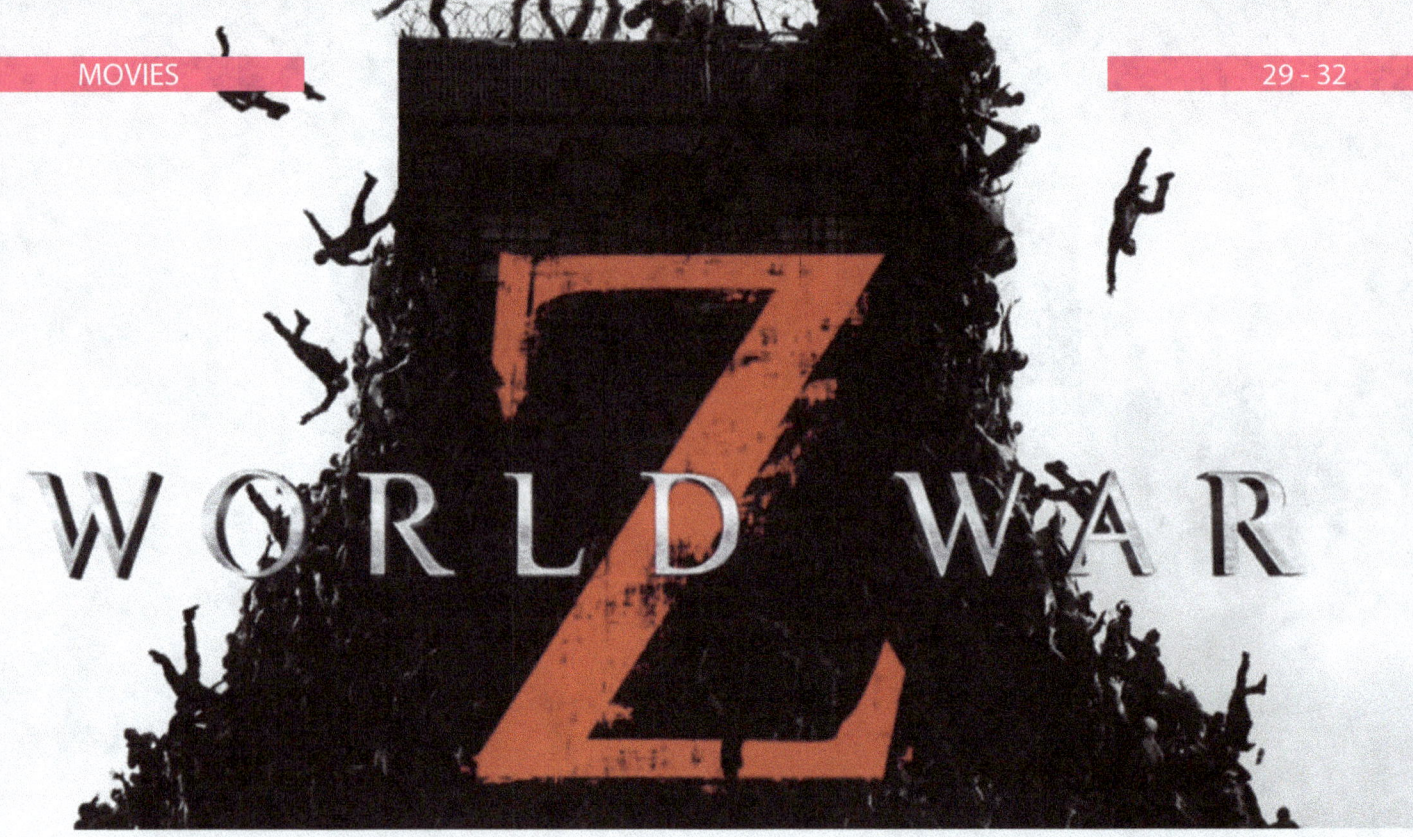

The Brad Pitt-starring **WORLD WAR Z** might have taken things to fantastical extremes, but the outbreak started just the same. In the 2013 movie, Pitt plays a former United Nations employee now working to find a cure for a fast-spreading flu virus. But that's not all. The virus, Solanum, first appears in China and then infects the world, turning its victims into sprinting zombies. Alongside the zombies attacking citizens and spreading further infection, in World War Z there is something called "The Great Panic", in which people take drastic measures to protect themselves. This includes stockpiling, quarantining, and even heading north amid rumours zombies can't survive in the cold. Whilst this all sounds a little familiar, we're sure that COVID-19 won't go as far as zombies...

MY SECRET, TERRIUS

In the tenth episode of this 2018 South Korean Netflix series, a Doctor explains his concerns about a flu-like virus that attacks the respiratory system. He says, "We must do more research, but it looks like a mutant coronavirus," so of course the internet blew up. A later scene even shows a class of children being taught how to effectively wash their hands – although no one sings "Happy Birthday". The term coronavirus has been used for decades to describe various virus strains, so we're not claiming My Secret Terrius has Simpsons soothsaying powers anytime soon.

TANGLED

This 2010 Disney Princess tale tells the classic story of Rapunzel, a young princess locked away in a tower for eighteen years. The main similarity some fans have found here is that the Kingdom in which Rapunzel lives is called Corona. Corona + lockdown in a tower = good point. Though Rapunzels's supposed quarantine led to her finding the love of her life, let's hope at least one of us can say the same. Perhaps we'll see love in the time of coronavirus after all?

STOP THE SPREAD

WASH YOUR HANDS FREQUENTLY

Regularly and thoroughly clean your hands with an alcohol-based hand rub or wash them with soap and water.

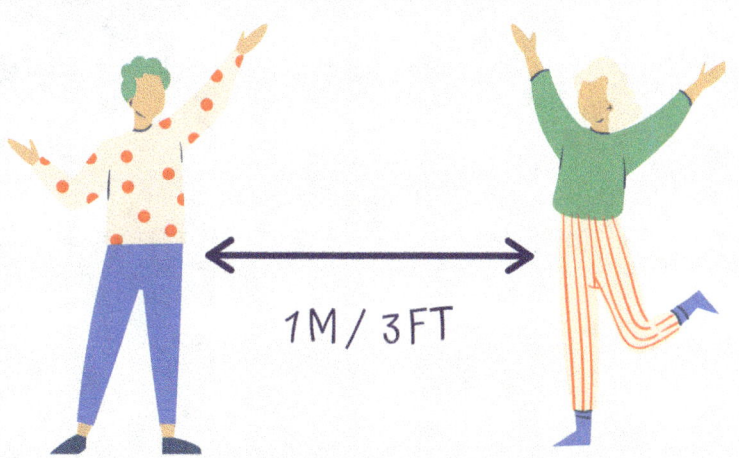

MAINTAIN PHYSICAL DISTANCING

Maintain at least 1 metre (3 feet) distance between yourself and anyone who is coughing or sneezing.

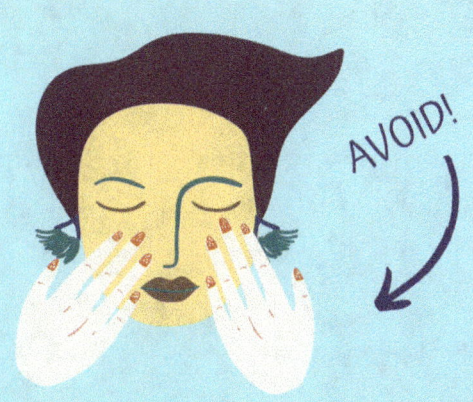

AVOID TOUCHING EYES, NOSE AND MOUTH

Hands touch many surfaces and can pick up viruses. Once contaminated, hands can transfer the virus to your eyes, nose or mouth.

IF YOU HAVE A FEVER, COUGH AND DIFFICULTY BREATHING, SEEK MEDICAL CARE EARLY

Stay home if you feel unwell. If you have a fever, cough and difficulty breathing, seek medical attention and call in advance.

Source: World Health Organization

AWARENESS

CELEBRATE EARTH DAY

Celebrate Earth Day by making a few easy changes the Earth will appreciate.
The first Earth Day (called May Day at the time) was held in 1970 in the US and it's often considered the start of the modern environmental movement.
In its simplest form, it's a day for people to step back, take a deep breath and appreciate Earth in all its splendor. But for many people Earth Day holds the potential to ignite broad environmental action.

1) START COMPOSTING

Live video posts are shown in a user's newsfeed with the volume muted by default. And since Facebook users typically scroll quickly through their feed, it's a risk your video will get lost in the crowd. It's therefore a good idea to include the occasional use of text in your lower thirds to provide a snapshot of what the video is all about and attract the attention of potential viewers.

All you have to do is create a compost pile in your backyard or, if you're a city slicker, store all your vegetable, fruit, and other natural scraps in a plastic bag in your freezer and then dump it when full at a compost collecting place.

2) PLANT A GARDEN

Plant some flowers and get a beautifully fragrant garden. And then plant some vegetables and get all the produce you need. Here's a guide to starting a garden.

3) BUY A TREE CERTIFICATE

Trees are amazing. But humans relentlessly chop and burn them down. So this Earth Day buy a certificate from Stand for Trees to protect a batch of trees somewhere in the world that's at risk of deforestation.

4) BECOME A BETTER GROCERY SHOPPER

First, get a reusable grocery bag to limit all the plastic produced in the world.

Then try to buy fresh foods that you can carry in reusable containers. For example, fresh fruits and vegetables don't come prepackaged. Also, nuts, lentils, coffee beans and many other dry goods can generally be purchased from bulk containers. By using reusable containers, you're further reducing the amount of plastic in the world.

Finally, try to buy local, ethical and environmentally sustainable products. If you can't go local, go ethical and sustainable.

The Earth is a truly marvelous place that provides all of us with life. As humans, we can surely do a better job taking care of it.

www.ingramcontent.com/pod-product-compliance
Lightning Source LLC
Chambersburg PA
CBHW080902010526
44118CB00015B/2237